えぞ ふくろうの きもち

横田雅博

4月ごろ、母親は樹洞（木の穴）で卵を生み30日ほどあたためます。
孵化したヒナは、1カ月ほど樹洞で育てられてから巣立ちます。
それから2〜3カ月、両親から狩りの方法や飛び方などを学び、その年の10月ごろに親から離れて独り立ちします。

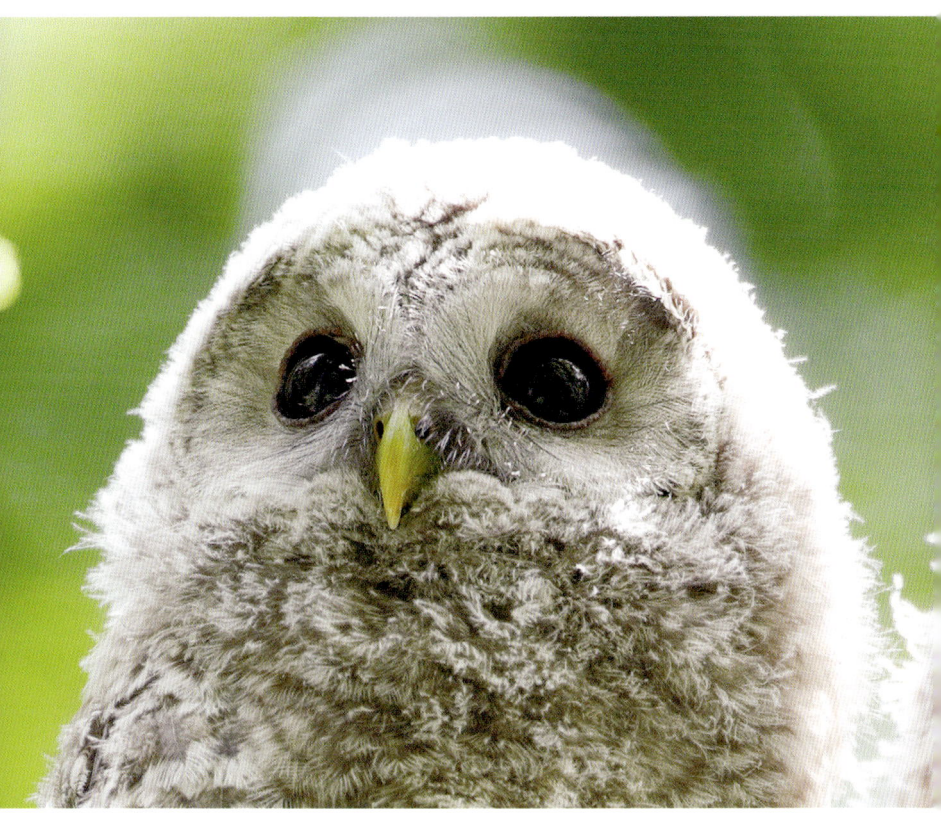

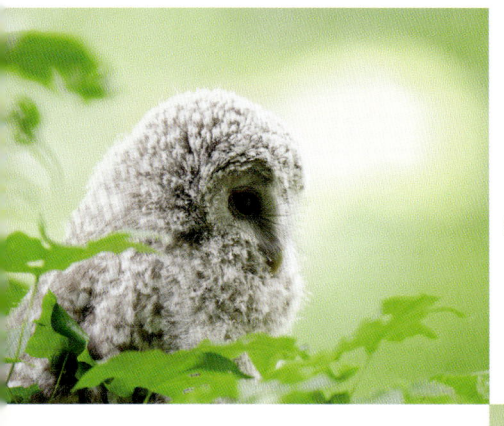

まだうまく
飛べないんだ…

ヒナは一度巣から出ると、もう巣には戻りません。
巣立ってすぐはまだ上手に飛べないので、何度も地面に落ちてしまいます。たとえ落ちても、丈夫な足の爪と口ばしを使って垂直な木も登ることができます。

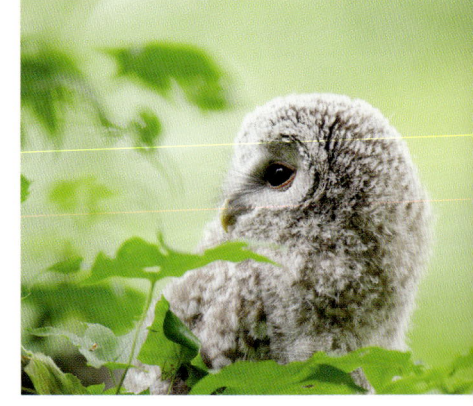

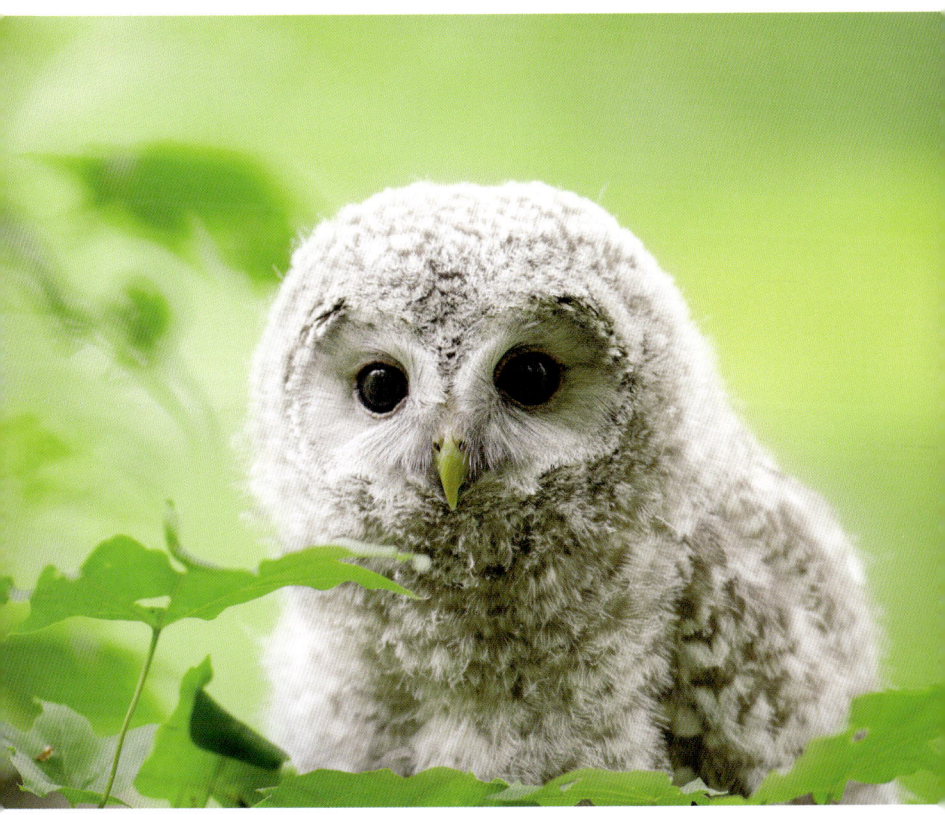

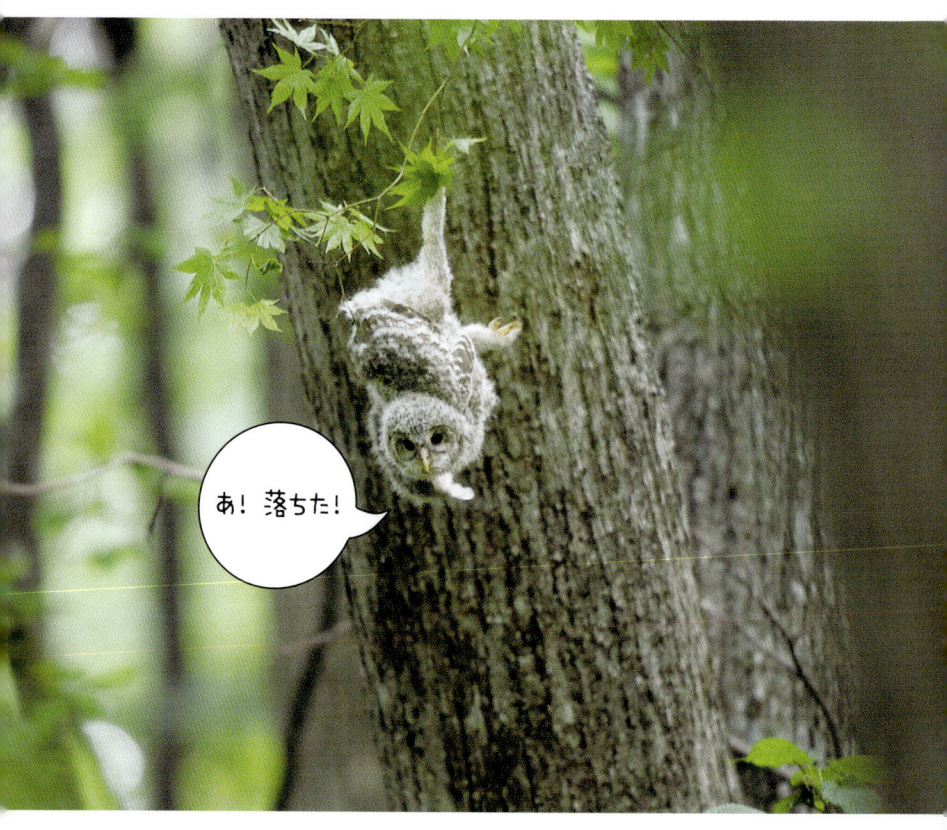

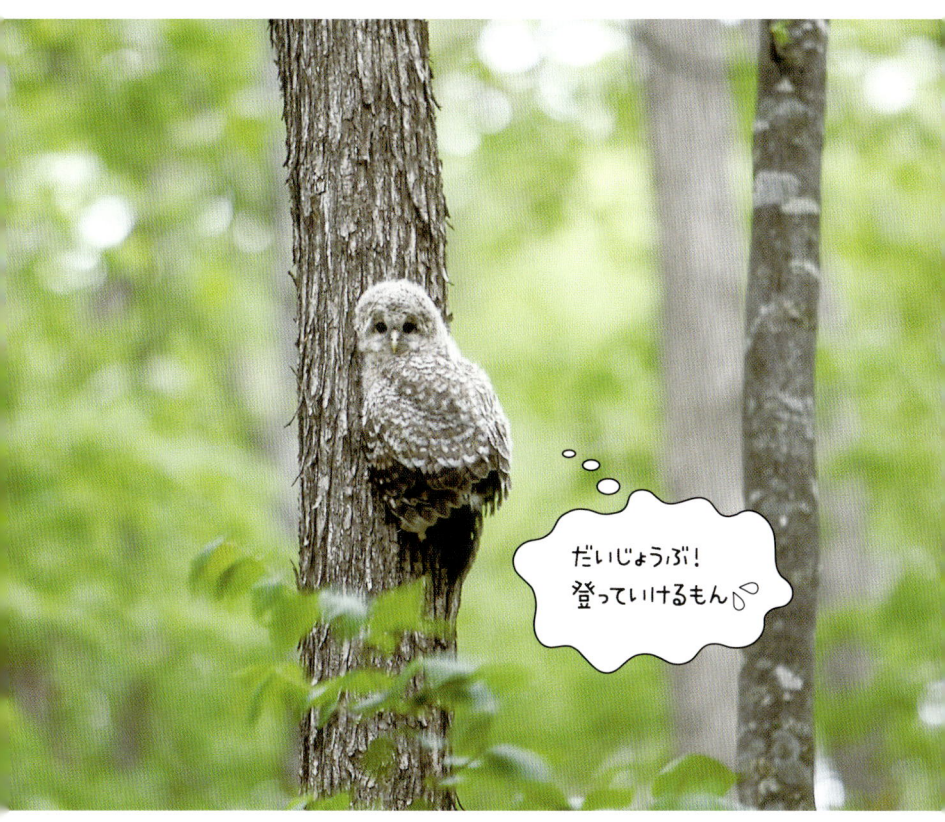

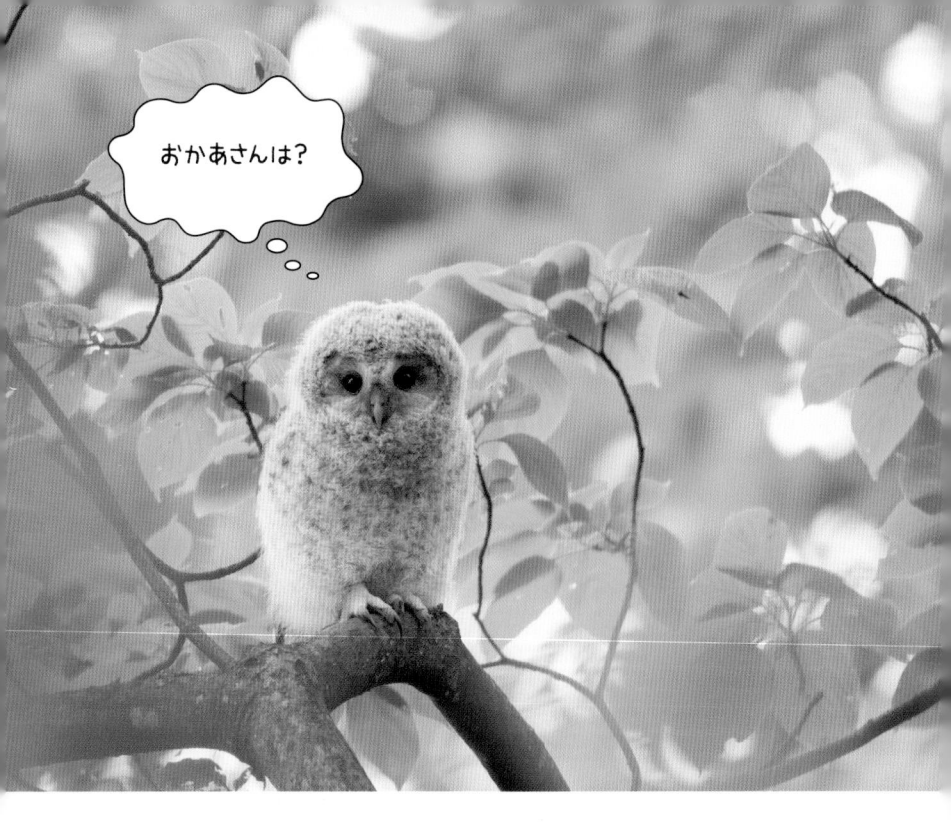

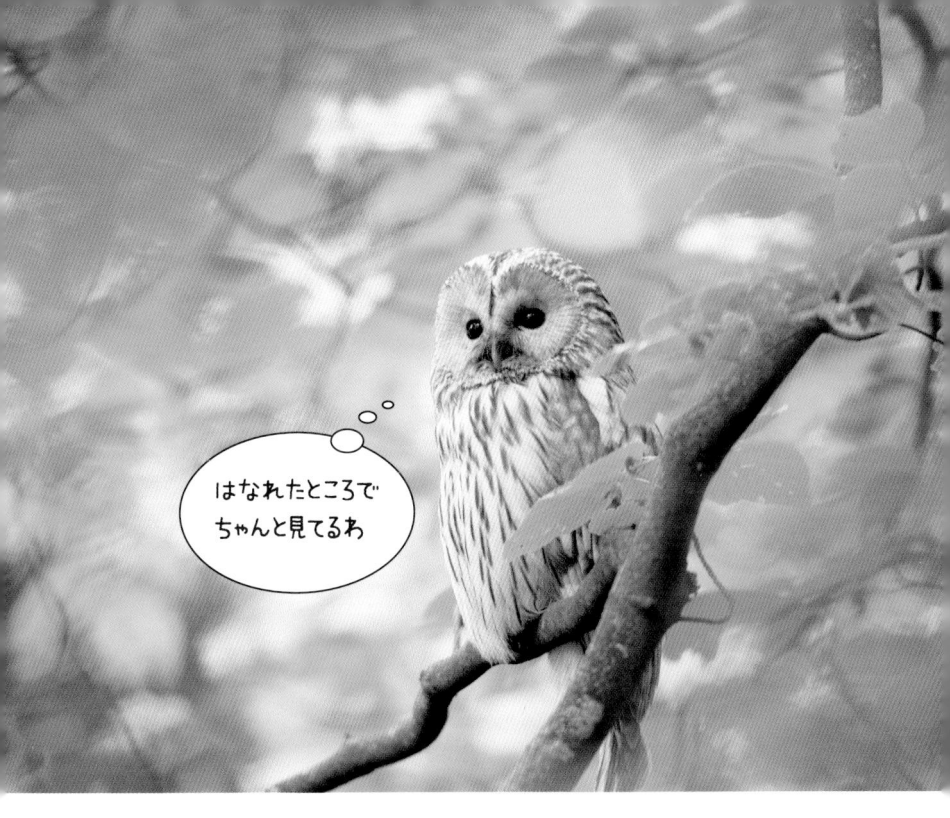

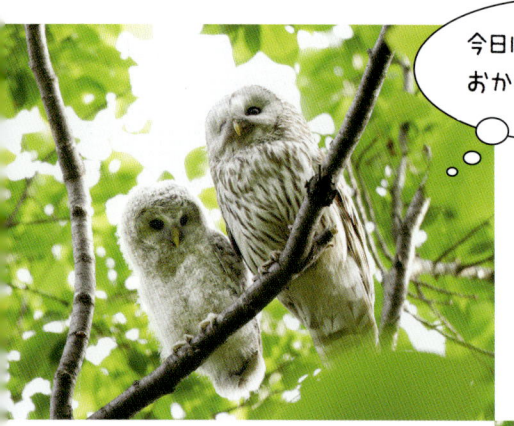

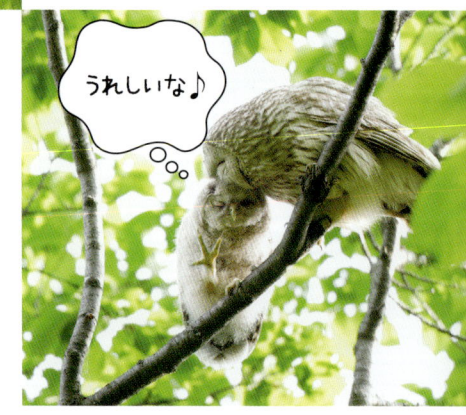

母親は近くの木の枝から子どもたちを見守っています。父親が持ってきたエサを受け取り、食べやすいように小さくして子どもに与えます。

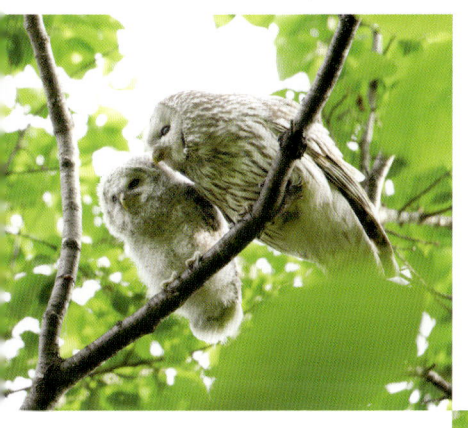

父親が夜が明けてもエサを運ばないと、母親に急かされます。
夜に雨や風が強くて狩りができなかった日は、昼近くになっても狩りをして子どもにエサを与えます。

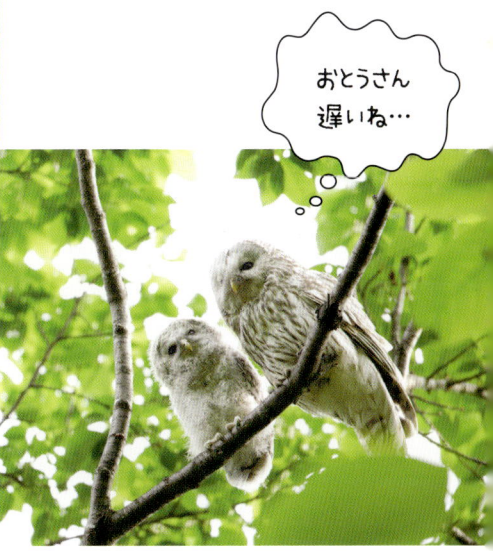

おとうさん遅いね…

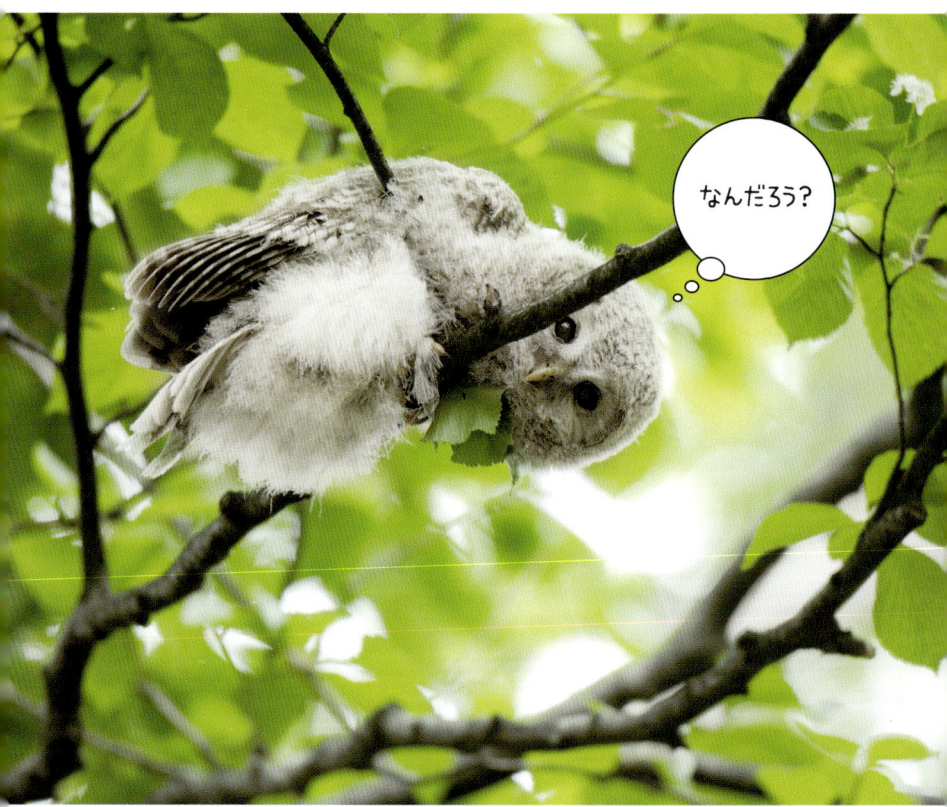

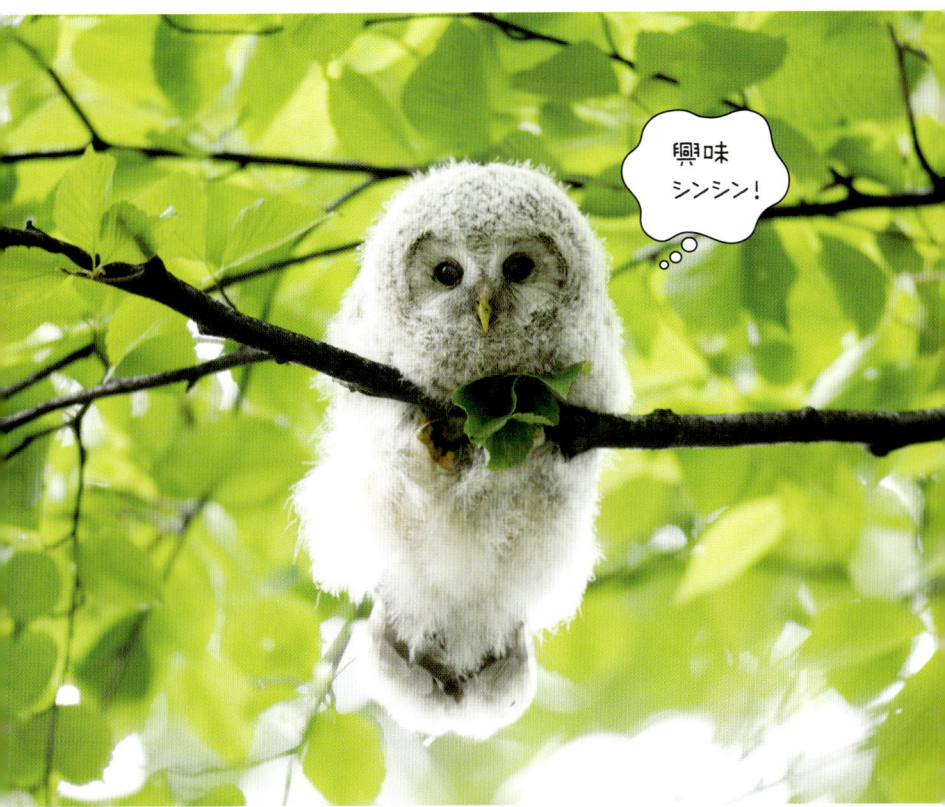

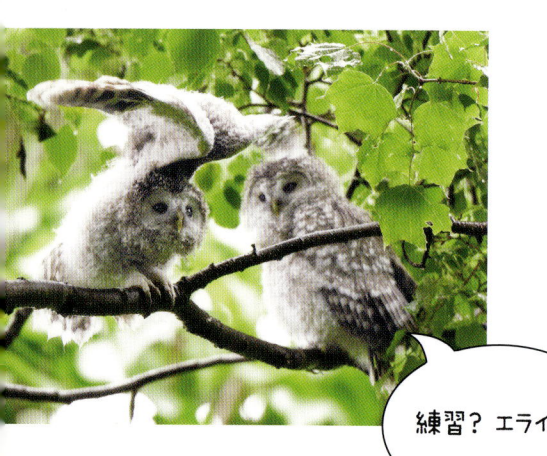

練習？ エライね

巣立ちから2週間くらいたつと、思った所に飛んで行けるようになります。すると、今まで別々の枝に止まっていた兄弟が、くっついて一緒にいるようになります。

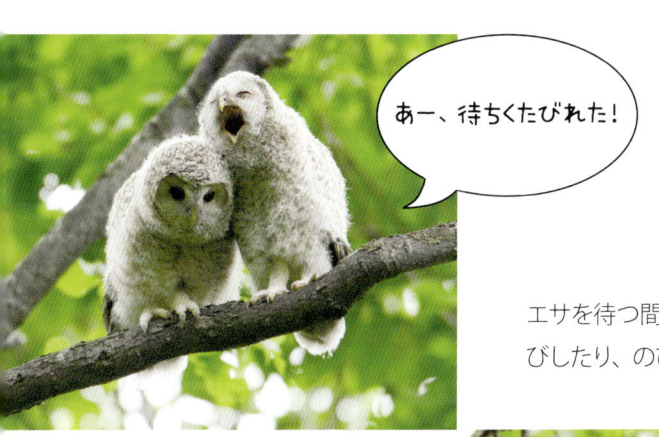

エサを待つ間は仲よく寝たり、あくびしたり、のびをしたりしています。

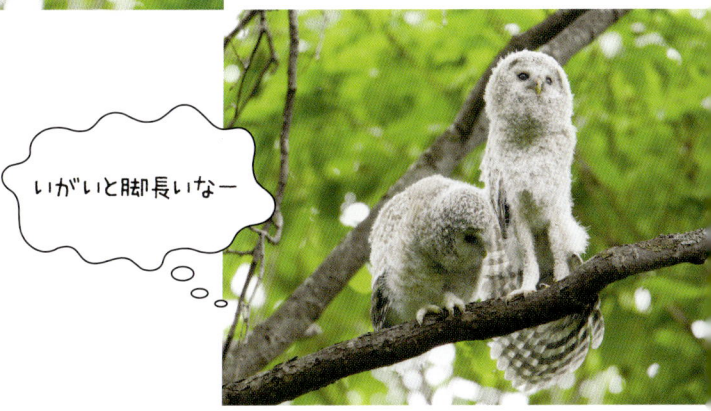

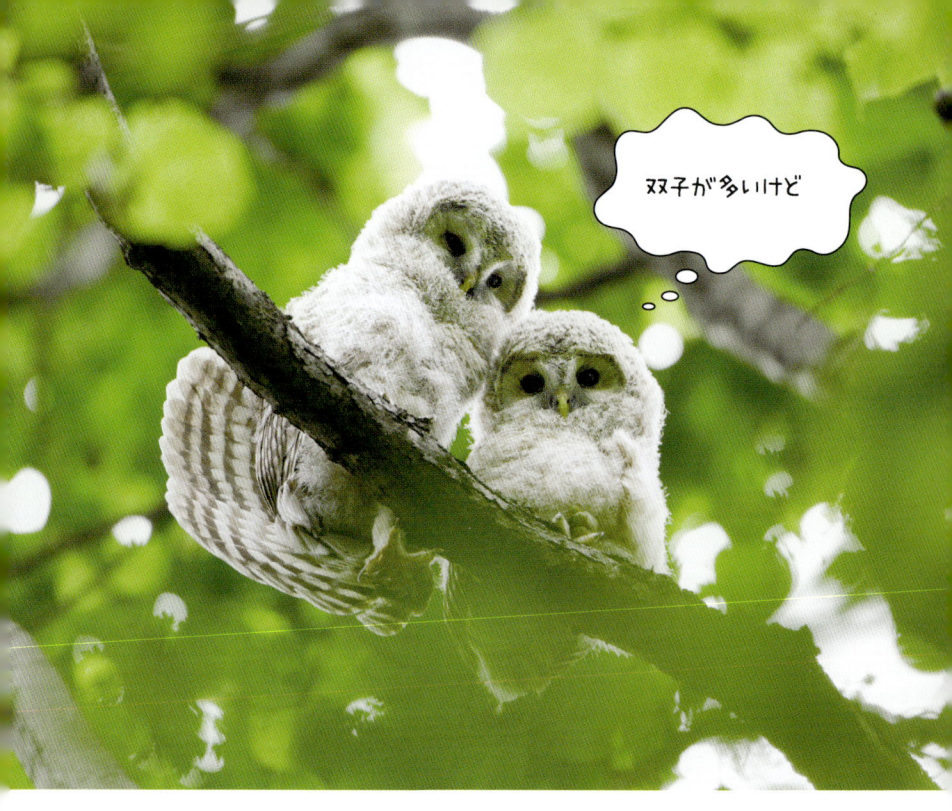

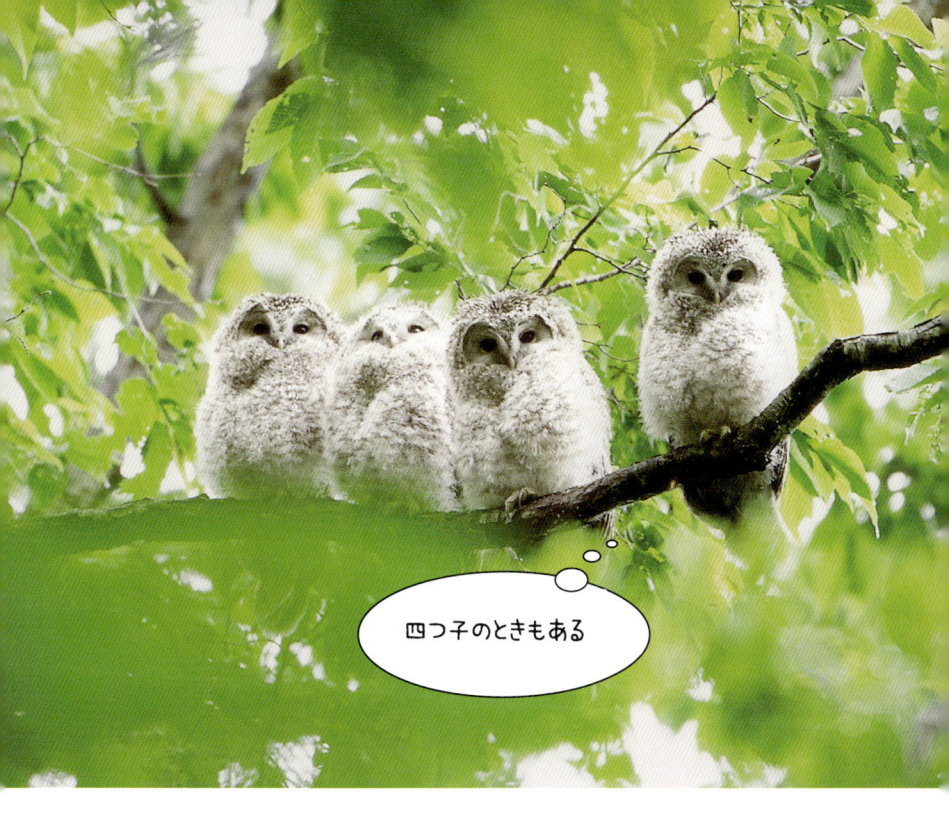

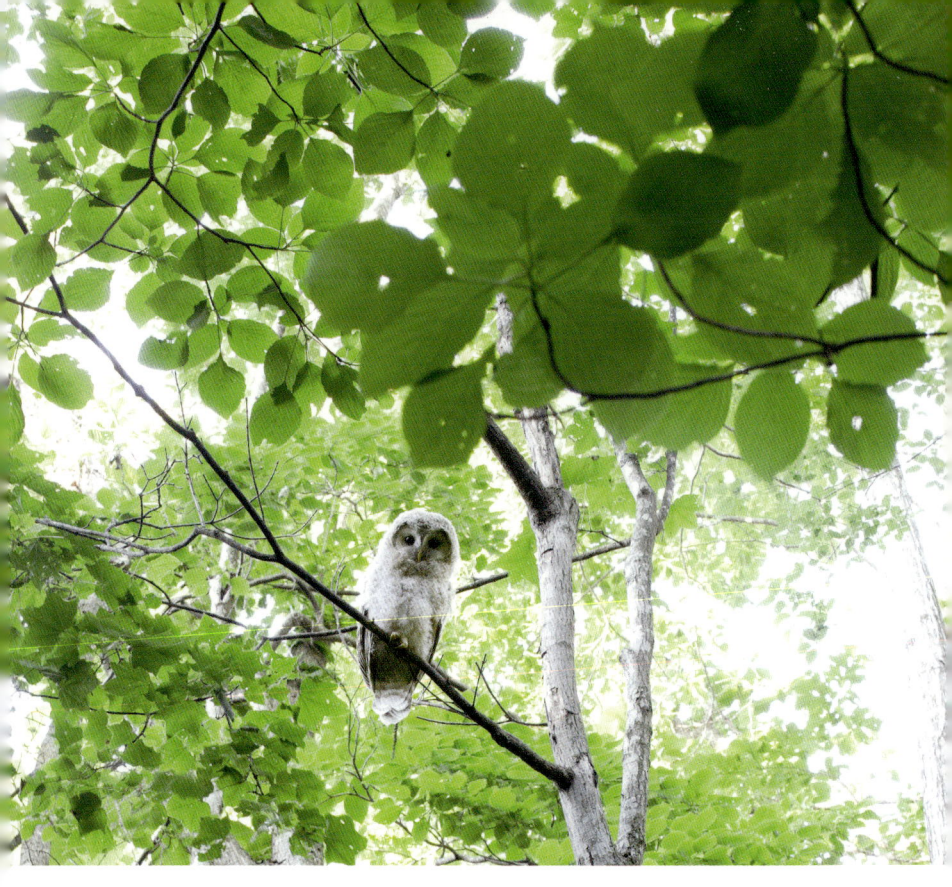

夏になると、羽や尾羽が伸びて随分と成長しました。もうかなり上手に遠くまで飛ぶことができます。

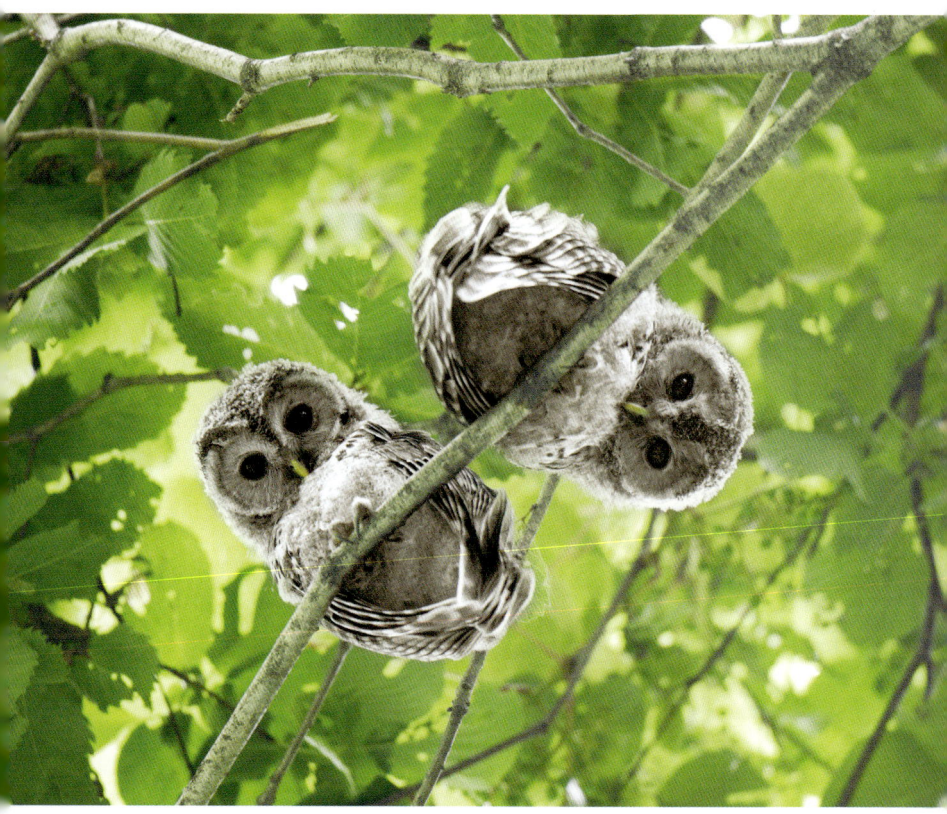

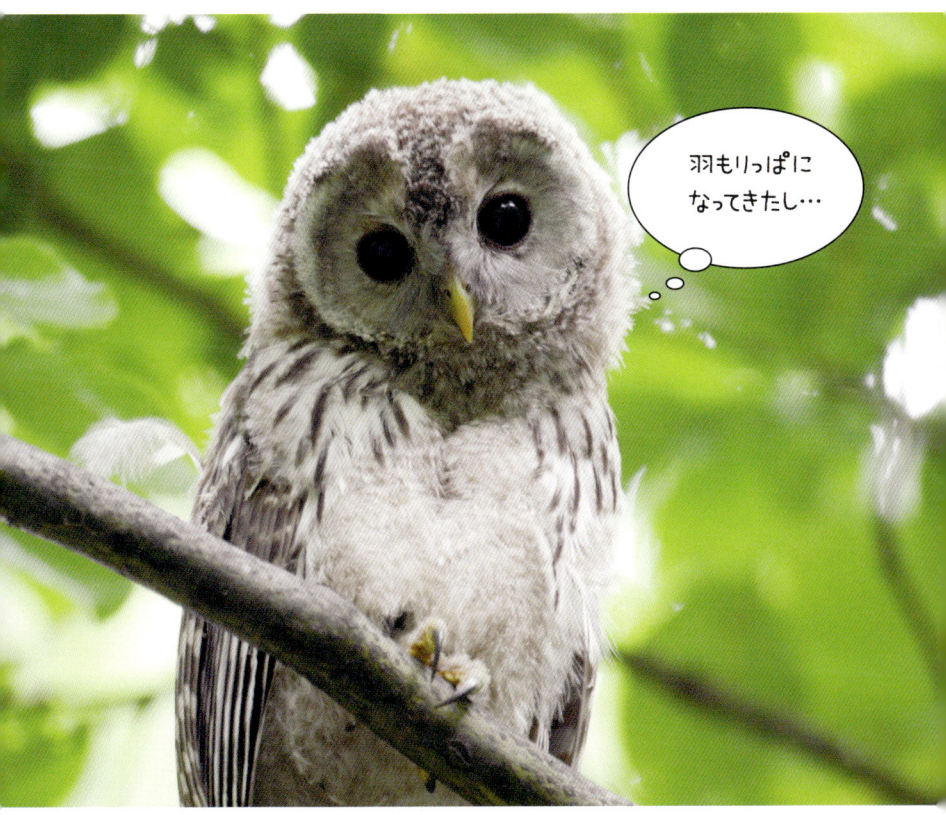

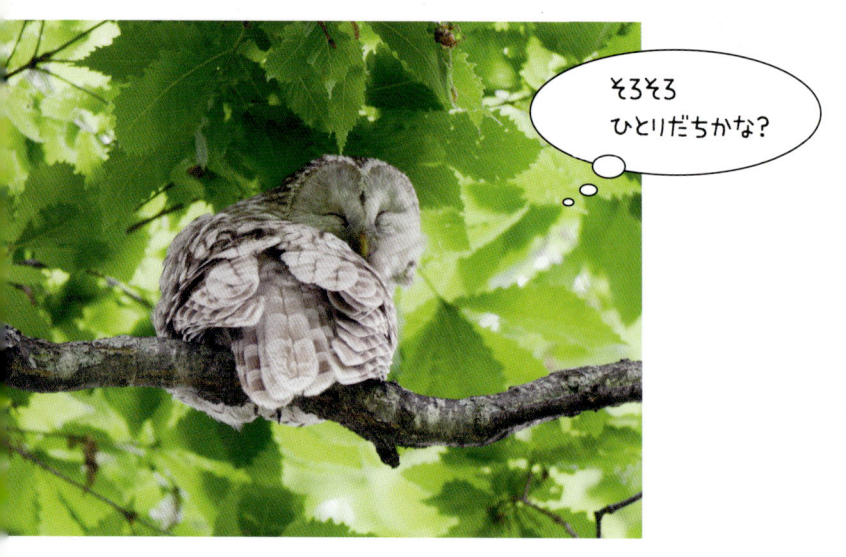

紅葉の季節がすぎて葉が散り始めるころに、突然別れがやってきます。親鳥はギャーという今まで聞いたことのない鳴き声を出して、自分の子どもを縄張りから追い払います。

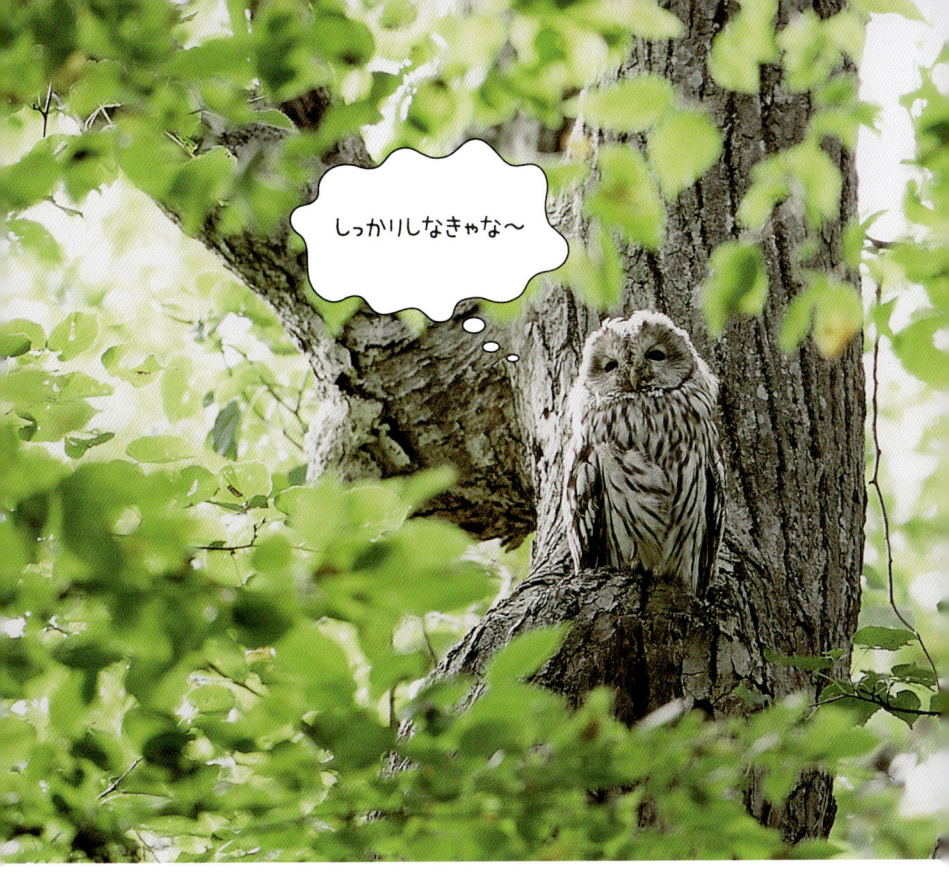

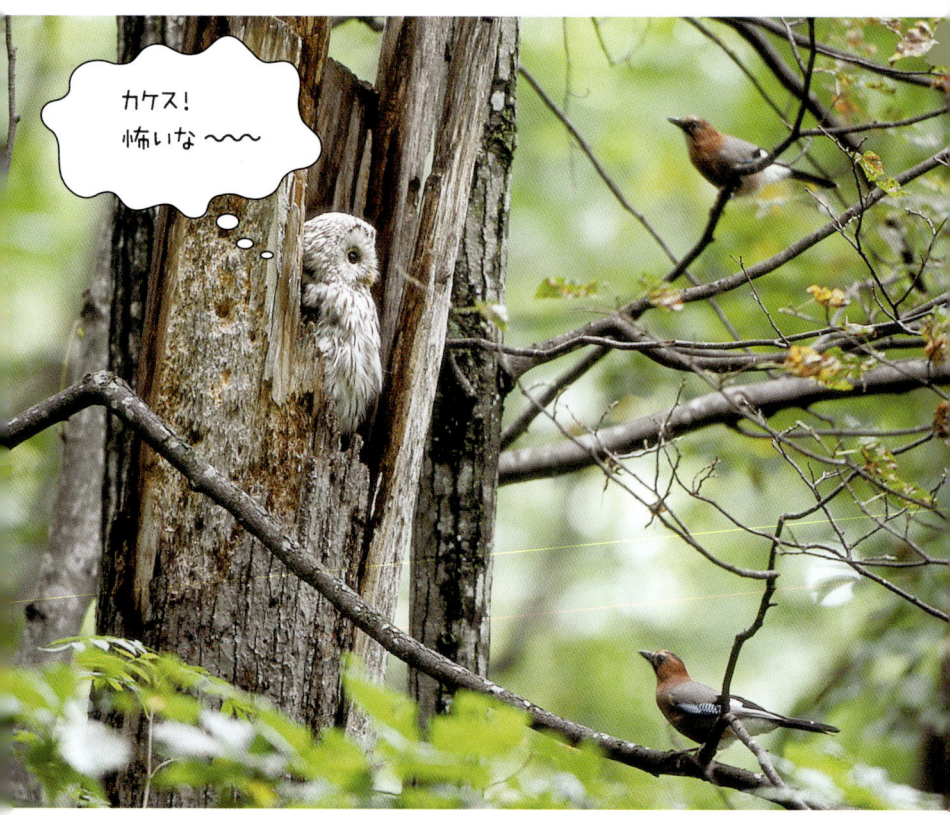

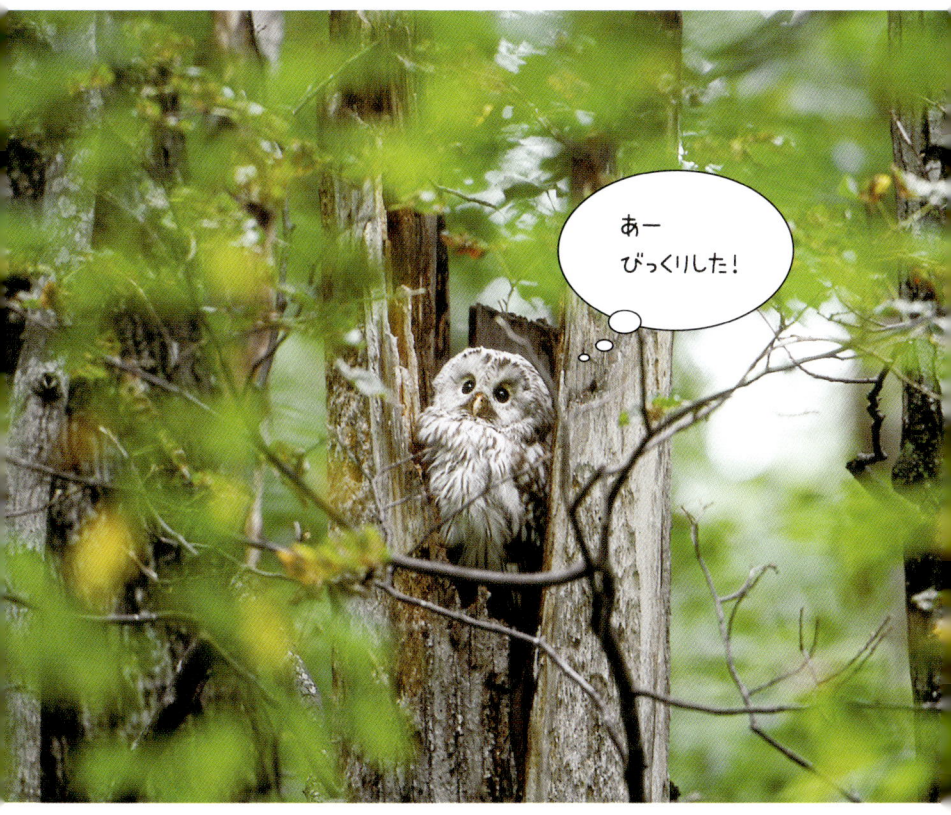

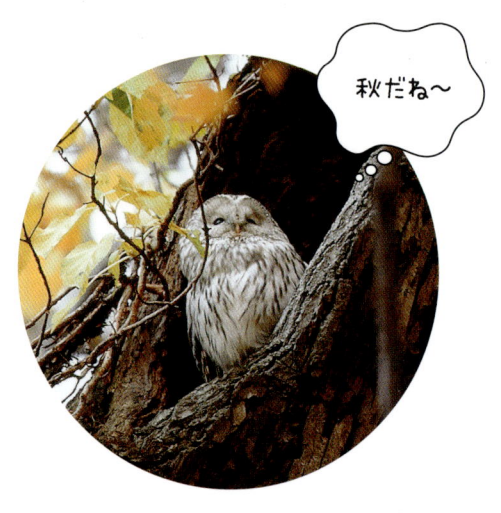

秋だね〜

フクロウは上空を飛ぶタカなどの猛禽をとても警戒します。
木々が葉を落とすと、隠れる場所が少なくなるため、樹洞ですごす時間が次第に長くなります。

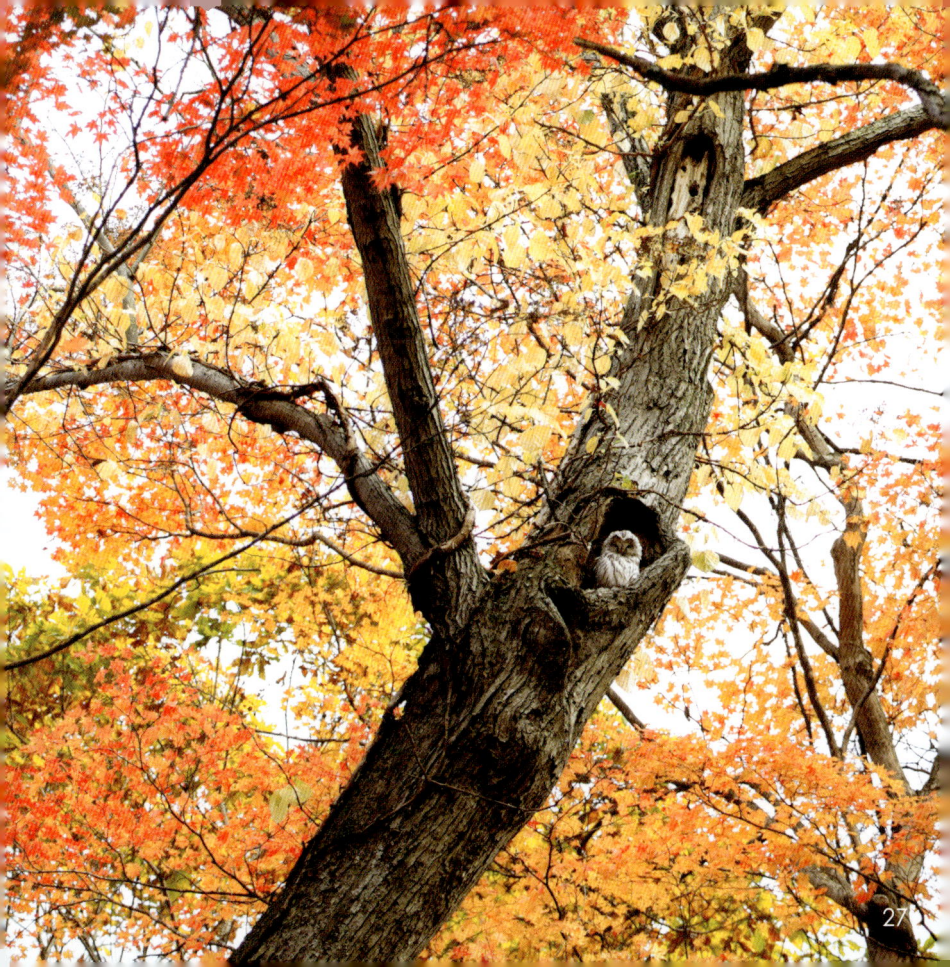

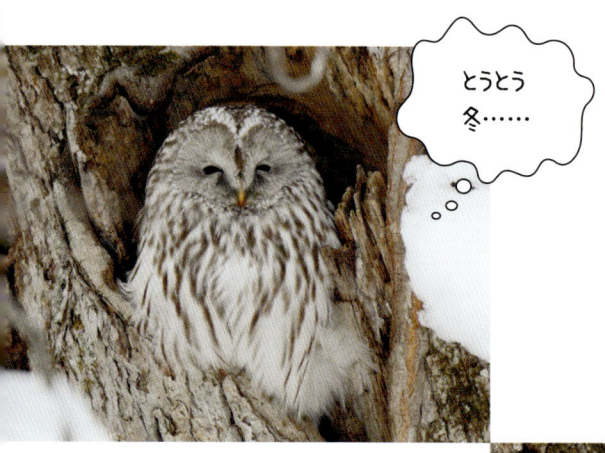

とうとう
冬……

雪が降り、一面真っ白になる冬が訪れます。
初めての冬のすごし方を、親は教えてくれません。生き方は自分で見つけなければいけません。

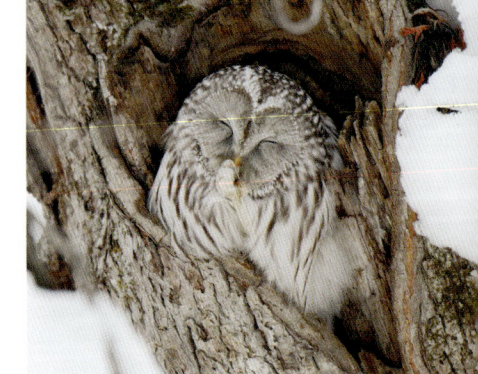

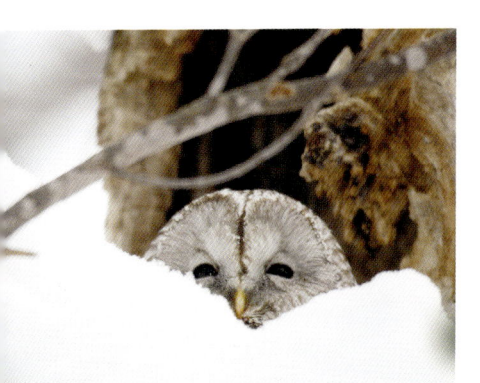
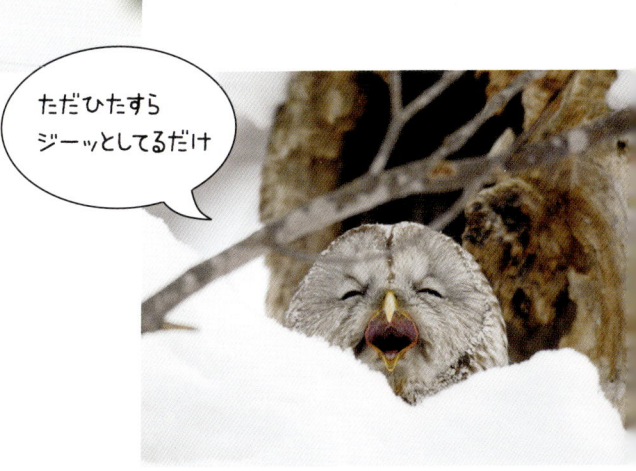

ただひたすら
ジーッとしてるだけ

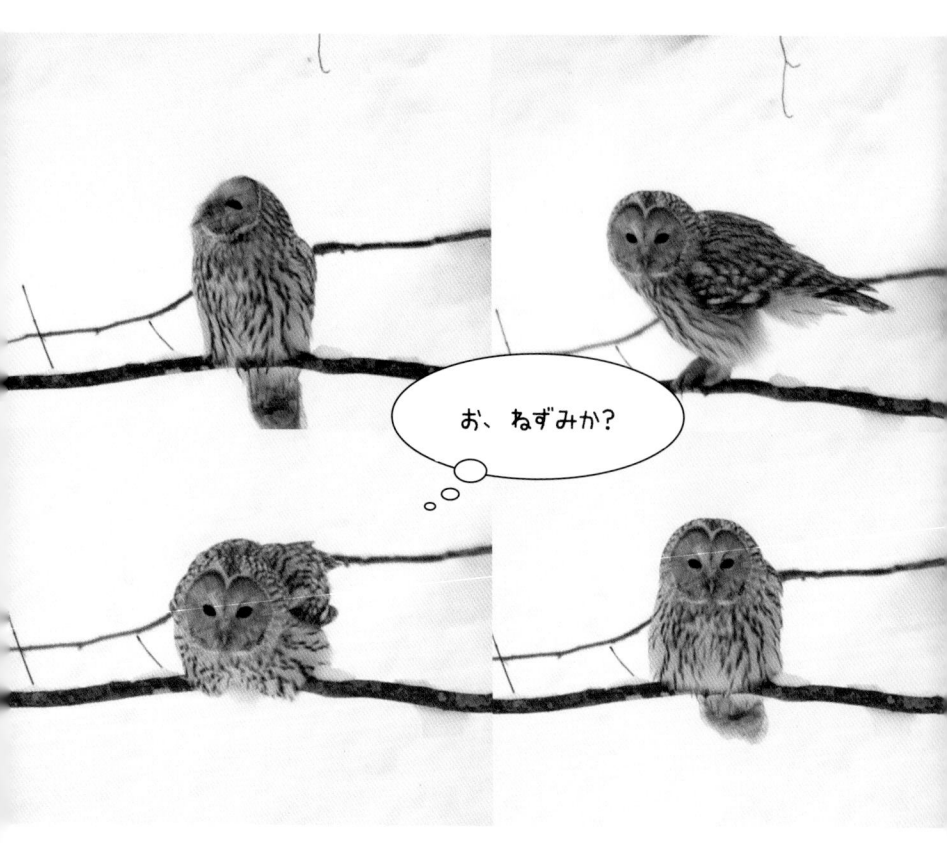

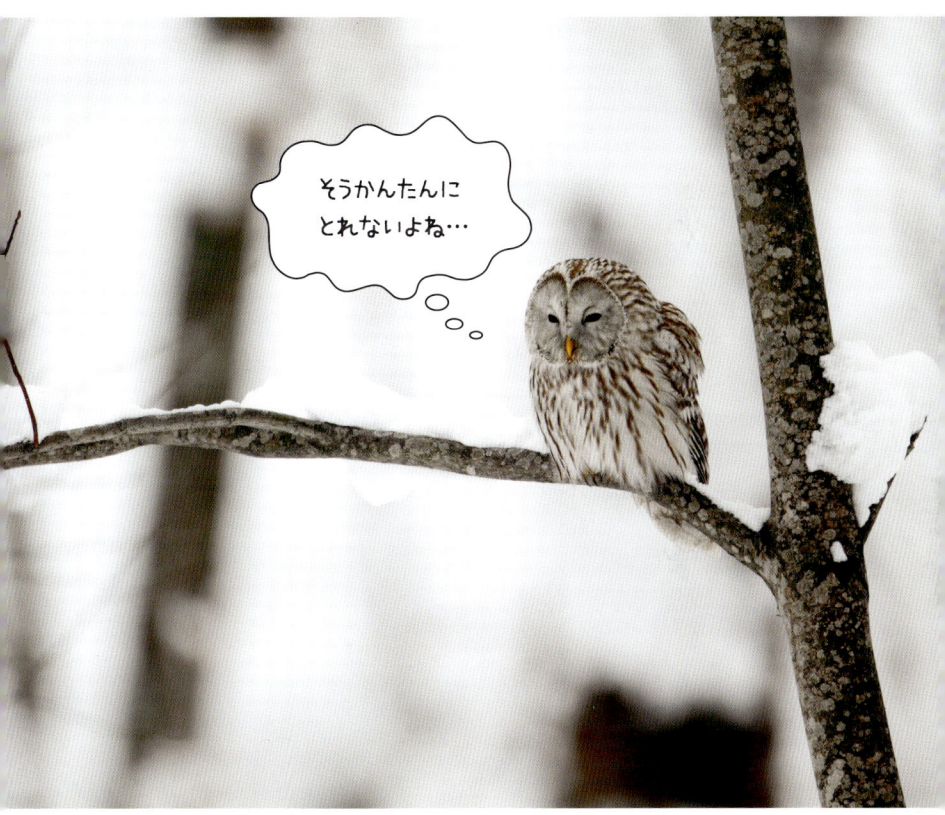

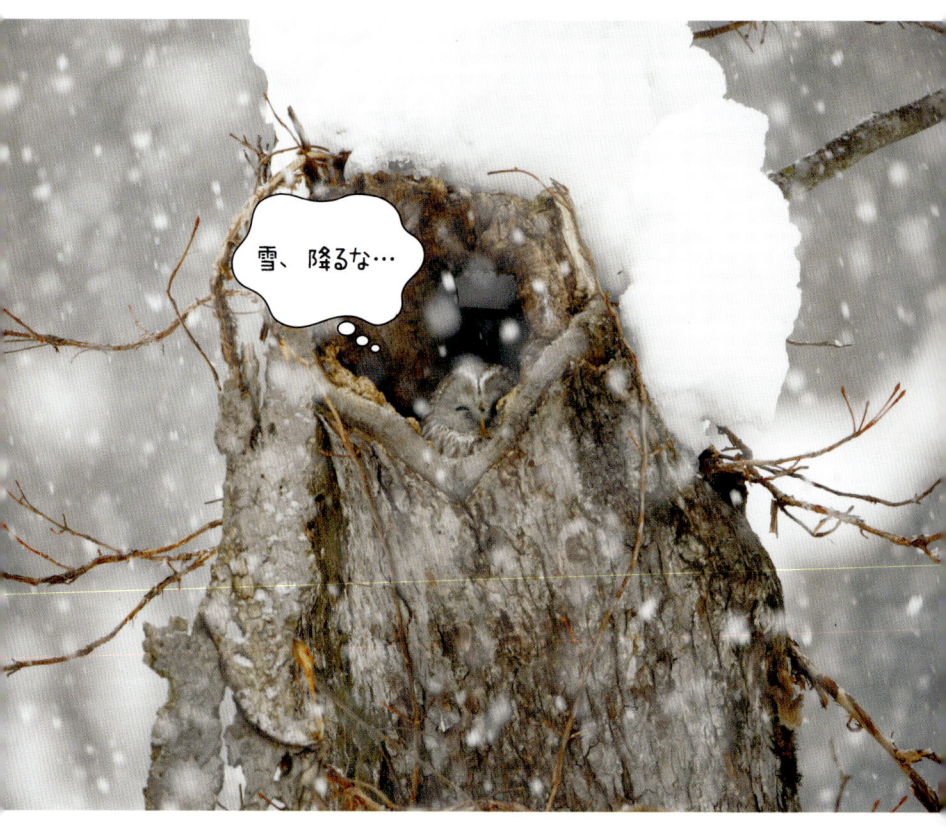

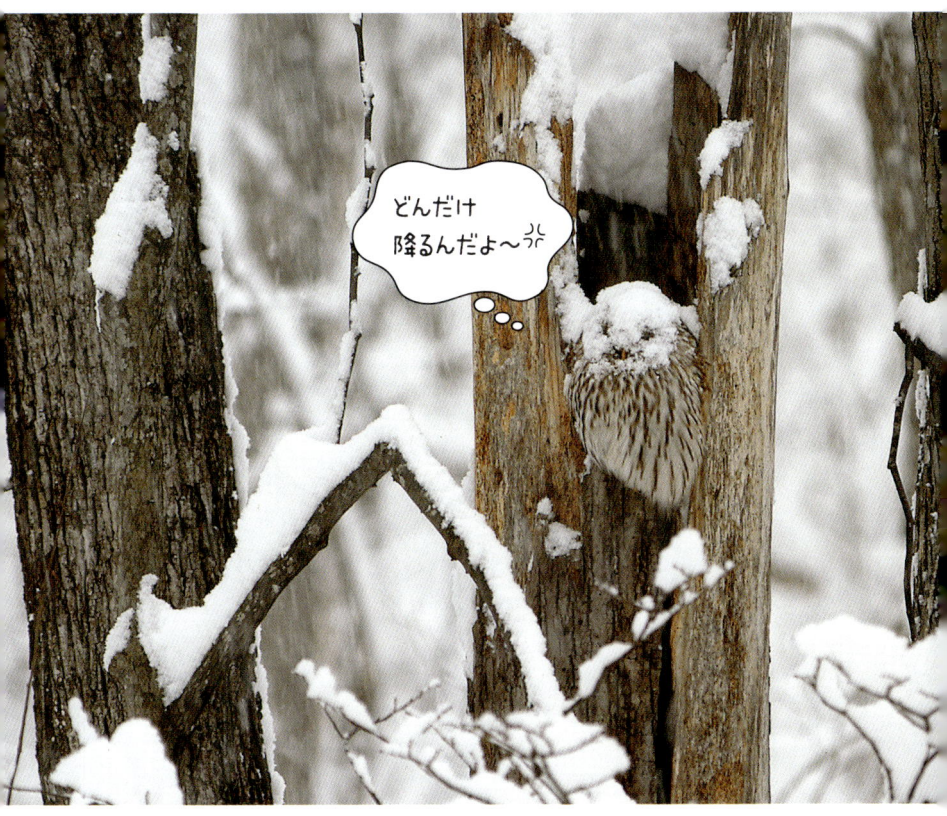

森いっぱいに白い雪が降り積もるころ、昼間はまったく行動しません。

春が近づく2月中旬から4月ごろが求愛と繁殖の季節。冬にとれるエサの量によって生む卵の数が決まります。

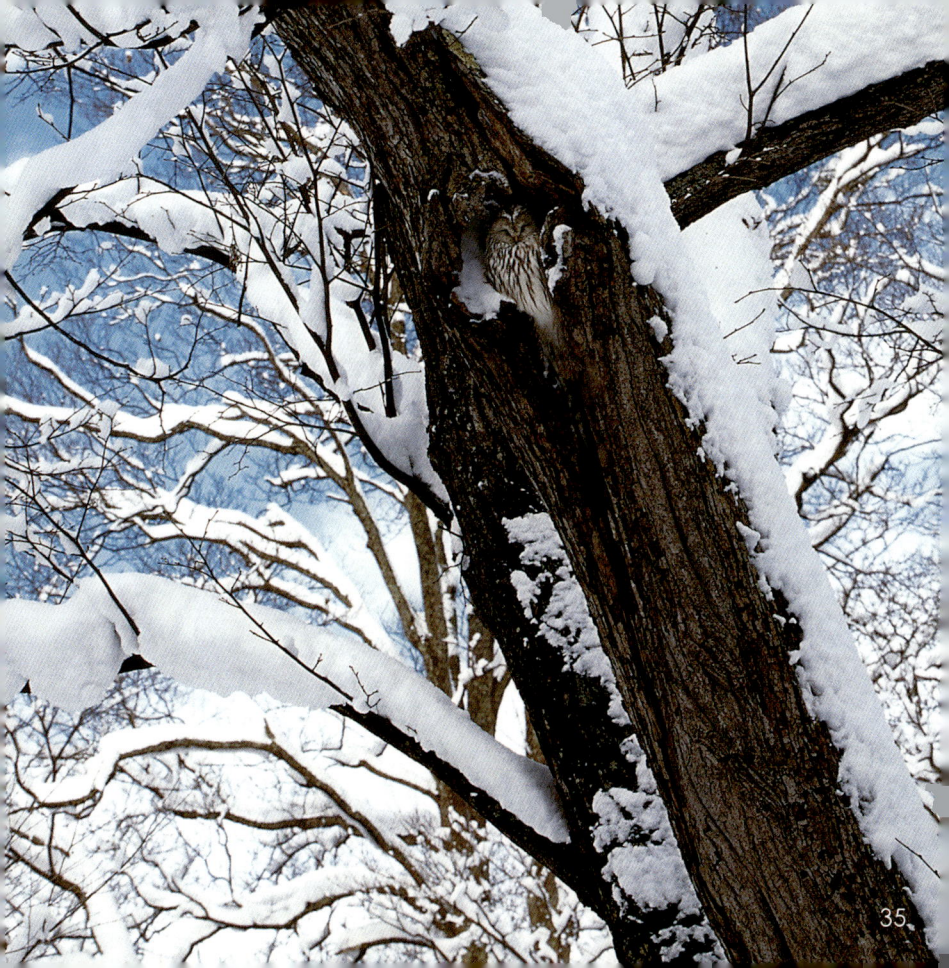

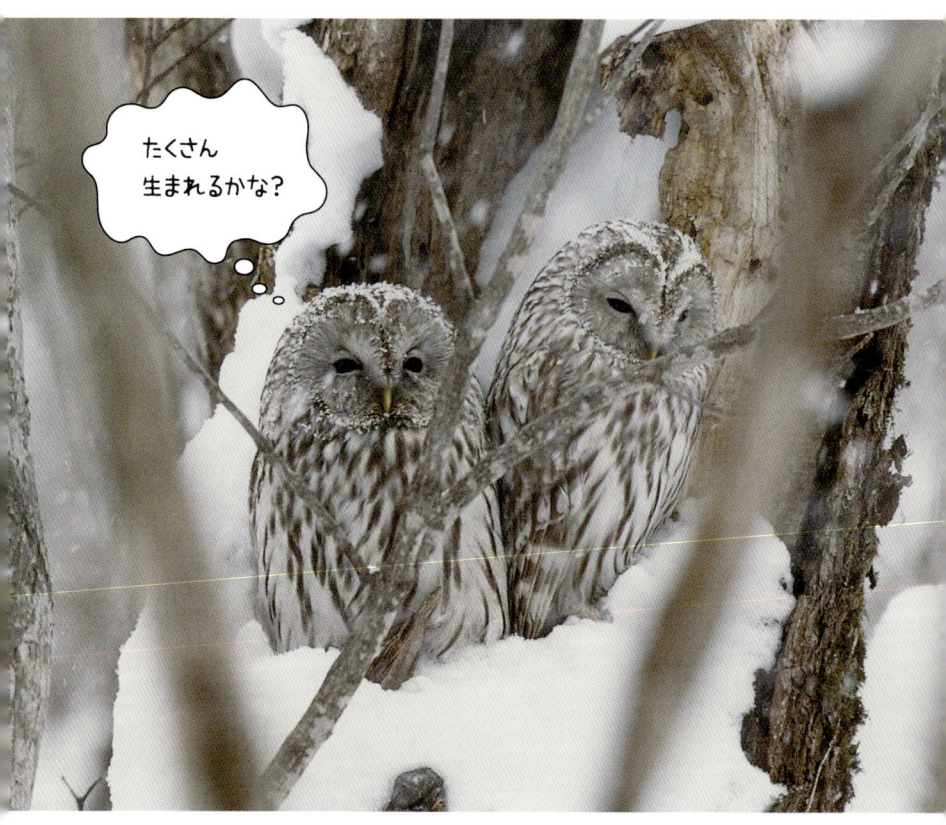

春になったら、また会えるね♪

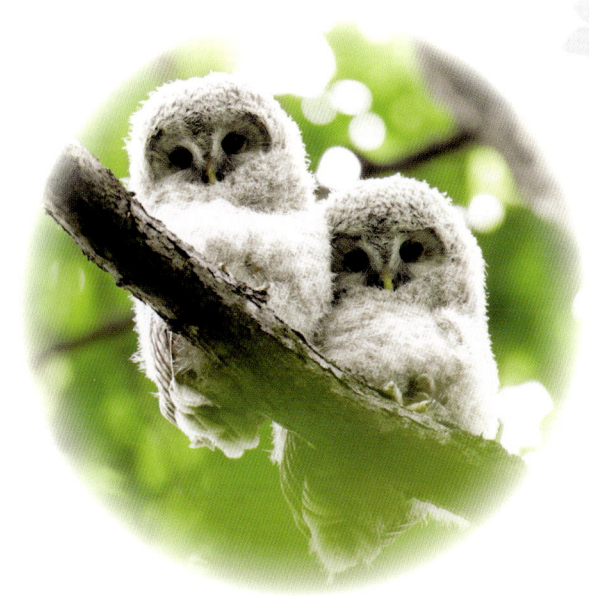

エゾフクロウのこと

フクロウ目　フクロウ科
英名 Hokkaido Fral Owl　学名 *Strix uralensis coreensis*

　フクロウは、スカンジナビア半島から日本にかけてユーラシア大陸の温帯から亜寒帯に広く生息し、留鳥として定住性が高いのが特徴です。日本には全国に分布していて、エゾフクロウ、ホンドフクロウ、モミヤマフクロウ、キュウシュウフクロウの4亜種が存在します。北の亜種ほど体色が白っぽく、南の亜種ほど暗色です。

　エゾフクロウは、森林近くの平地から山間部に生息し、人間をあまり恐れないため、里山や大木がある社寺林や公園などで見られることも多いです。

　全長は 50～60 cmで、シマフクロウに比べるとかなり小柄ですが、日本でみられるフクロウ類では大柄な方です。羽角（耳みたいな毛）はなく、虹彩はミミズクのような黄色ではなく黒いのが特徴です。

　単独、またはつがいで行動し、夜行性で昼間は樹洞や木の枝で休息しています。日が落ちてから活動を始めますが、子育て時期には日中も行動します。肉食でネズミや小型の鳥類、昆虫、両生類やは虫類などを食べます。

あとがき

　命を育み、やさしく、時には厳しい時間を与える森。緑風が通り抜ける森は生命を育む動物の棲み家です。エゾフクロウやエゾリス、春に渡ってきた鳥などの動物たちが暮らします。緑葉の上からは、今年生まれた者の喜びの歌声が響きます。エゾフクロウは冬以外は、樹洞ではなく枝の上で暮らします。葉が繁って外敵に見つかりづらい所が好きなようです。母親は近くの木の枝から子どもらを見守っています。父親は子どもたちにエサを与えるため、春から夏にかけて昼も狩りに出かけて行きます。子育ての姿と表情からは、人間と変わらない愛情を感じます。

　広葉樹の森へ行くことは、樹々を屋根、草花を襖にした動物たちの家に入って行くように感じられます。伐採され「木材」の畑として松や杉などが植えられた地面まで光が届かない植林は、一見すると緑色ですが、食べ物も巣材もなく、多くの動物たちは棲むことができません。森は渡り鳥にとっては巣材を集める所であり、子育てのための大切なエサ場でもあります。リスもウサギも広葉樹がなければ暮らしていけません。そしてエゾフクロウにとっては、地面から木々の樹冠までの限られた空間だけが生活の場所です。動物の棲み家である広葉樹の森がいつまでも残ることを願っています。

横田 雅博 (よこたまさひろ)

1960年生まれ、札幌市在住。1990年から森を中心とした自然写真の撮影を始める。森は木や草花だけでなくそこに生きる動物も森の仲間であることに気づき、四季を通じて森に生きるフクロウの姿に魅せられ撮影している。著書に、フォトブック「こころが軽くなる贈り物」(経済界)、写真集「愛しきものエゾフクロウ」(青菁社)など多数。http://northland-photo.jp/

ブックデザイン・DTP 蒲原裕美子 (時空工房)

えぞふくろうのきもち

2016年 4月20日　　初版第1刷発行
2022年 6月 1日　　初版第3刷発行

著　者　　横田雅博
発行者　　菅原　淳
発行所　　北海道新聞社
　　　　　〒060-8711　札幌市中央区大通西3丁目6
　　　　　出版センター　(編集) TEL　011-210-5742
　　　　　　　　　　　　(営業) TEL　011-210-5744

印刷・製本　　株式会社アイワード

落丁・乱丁本は出版センター (営業)にご連絡下さい。お取り換えいたします。
© MASAHIRO yokota 2016 Printed in Japan
ISBN978-4-89453-823-8